DOG LOVERS

ADULT COLORING BOOK

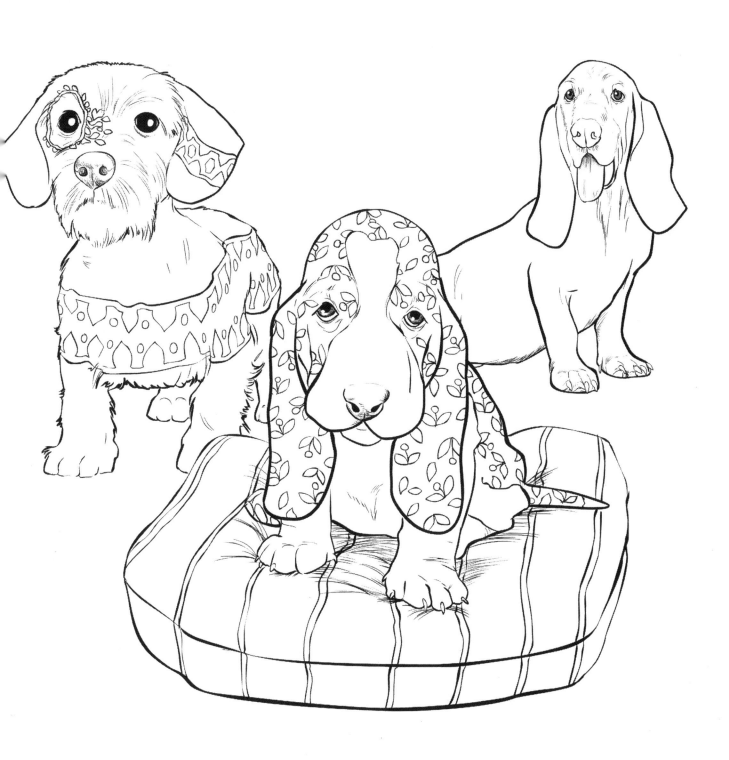

Published in 2016 by
Createspace
Email:tamercindy@selahworks.com
Website: www.selahworks.com
Cover Design by Cindy Elsharouni
Book Design Tamer Elsharouni

Printed in the U.S.A.

ISBN-10: 1535098856
ISBN-13: **978-1535098854**

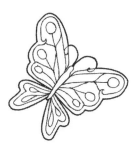

Get your coloring supplies ready to bring these canine beauties to life. These imaginative and decorative pages feature breeds from boxers, pitt bulls, yorkies to even the pharaoh hound, to name a few. Some are intricately designed with patterns wrapping around their figures while others are free for your own imaginative creativity. All are artistically layed out with designs to complete a beautiful display.

Share Your Amazing Creations Here!

And stay updated with new books

https://www.facebook.com/AdultColoringBooksSelahWorks/

Be sure to visit our website www.selahworks.com

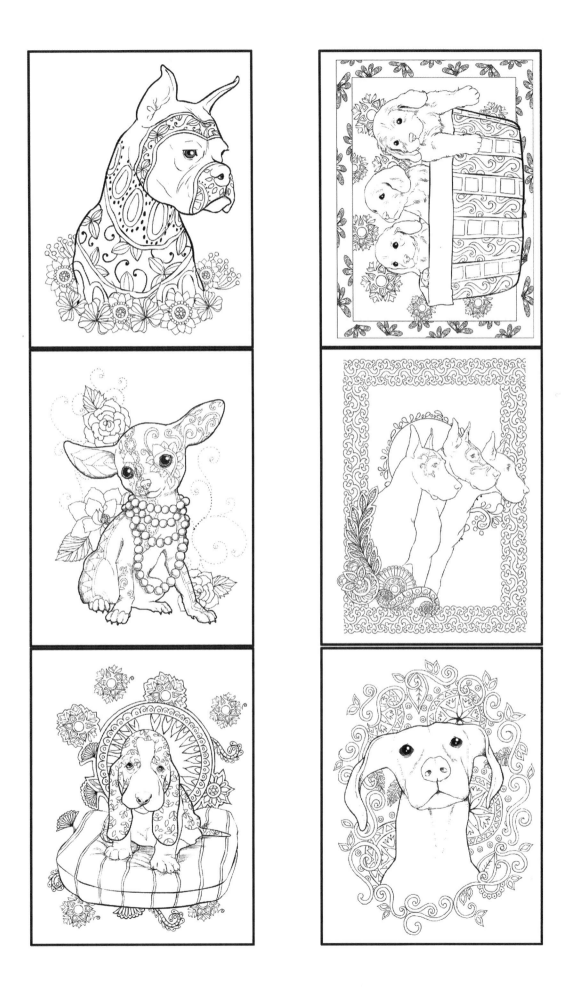

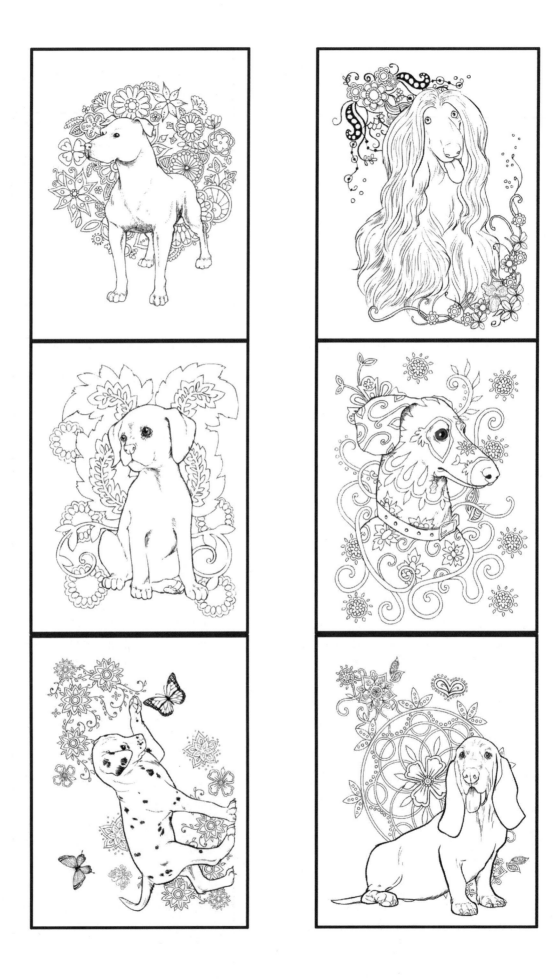

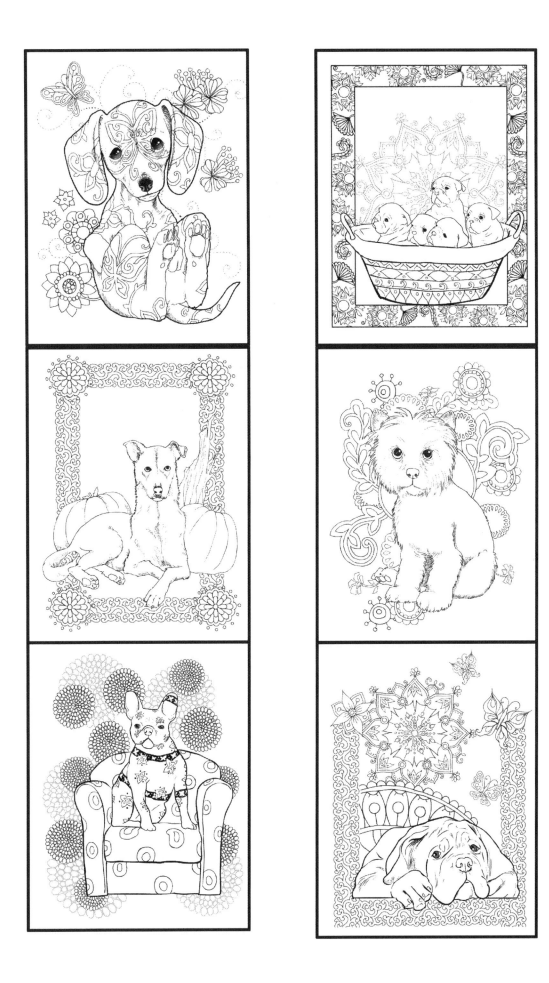

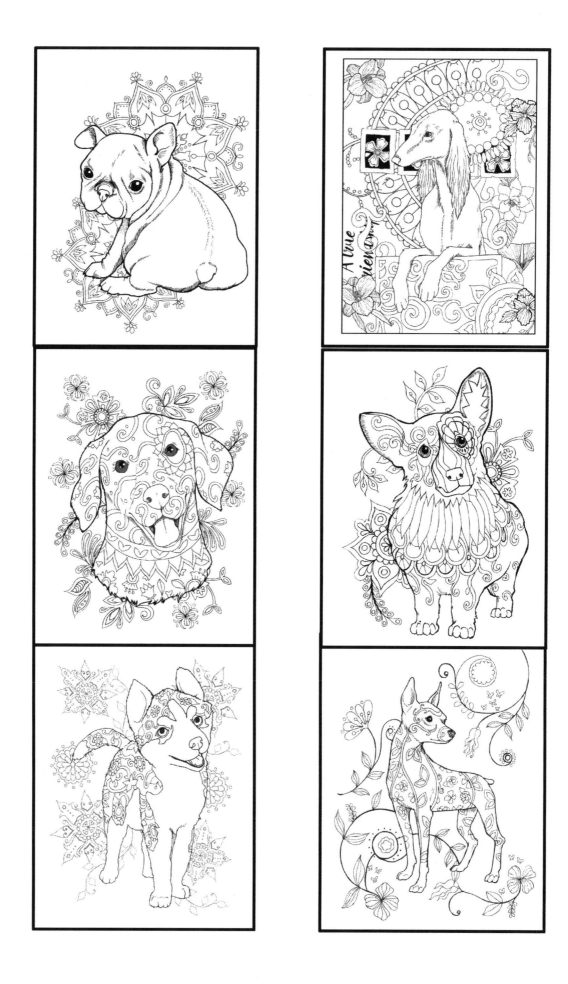

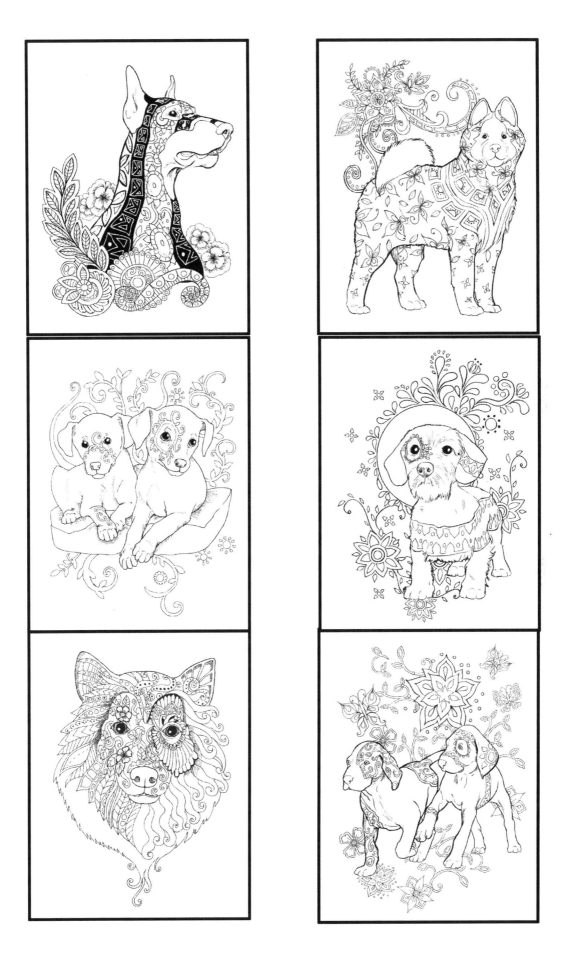

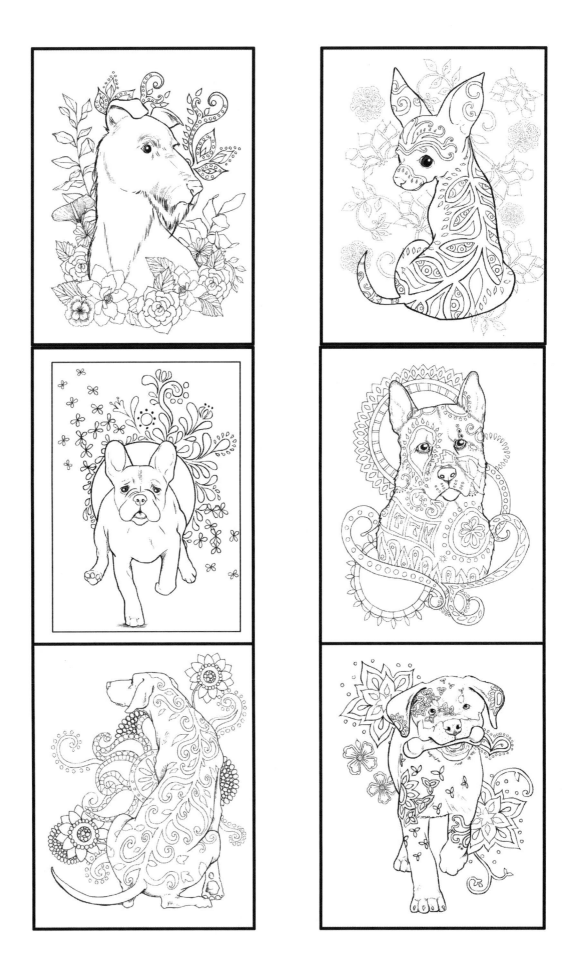

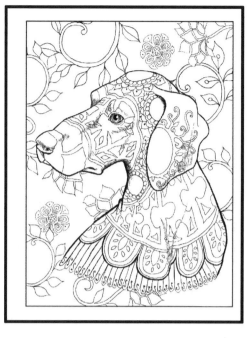

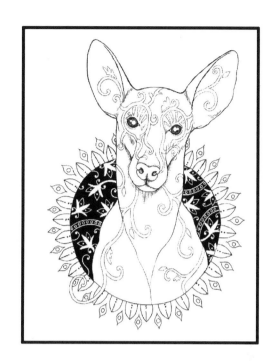

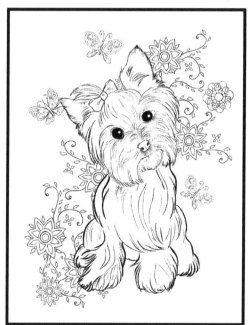

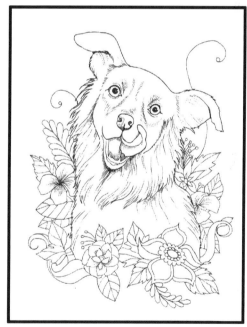

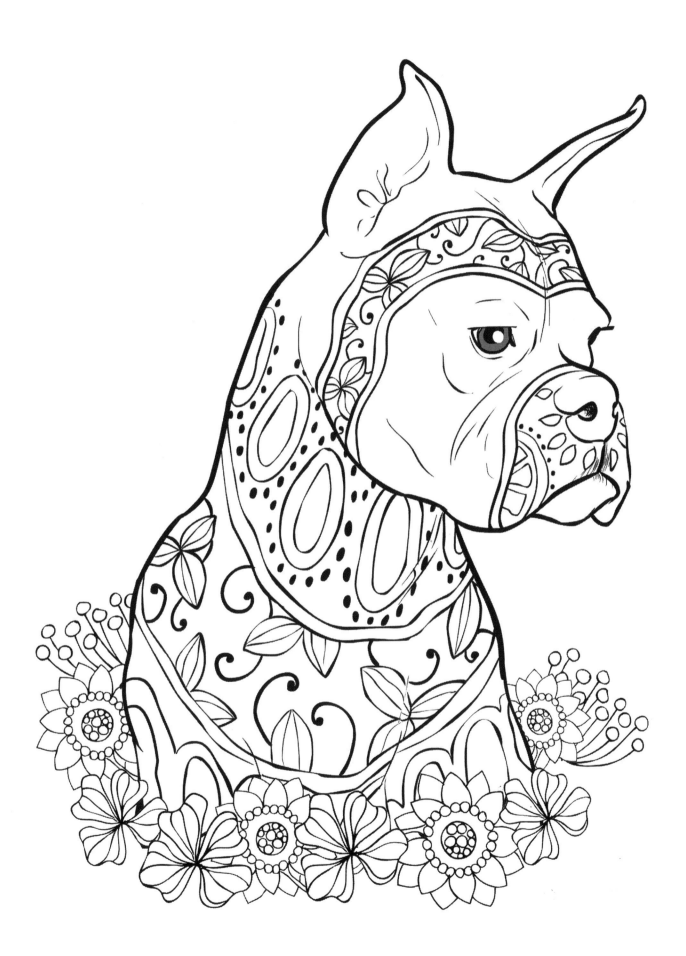

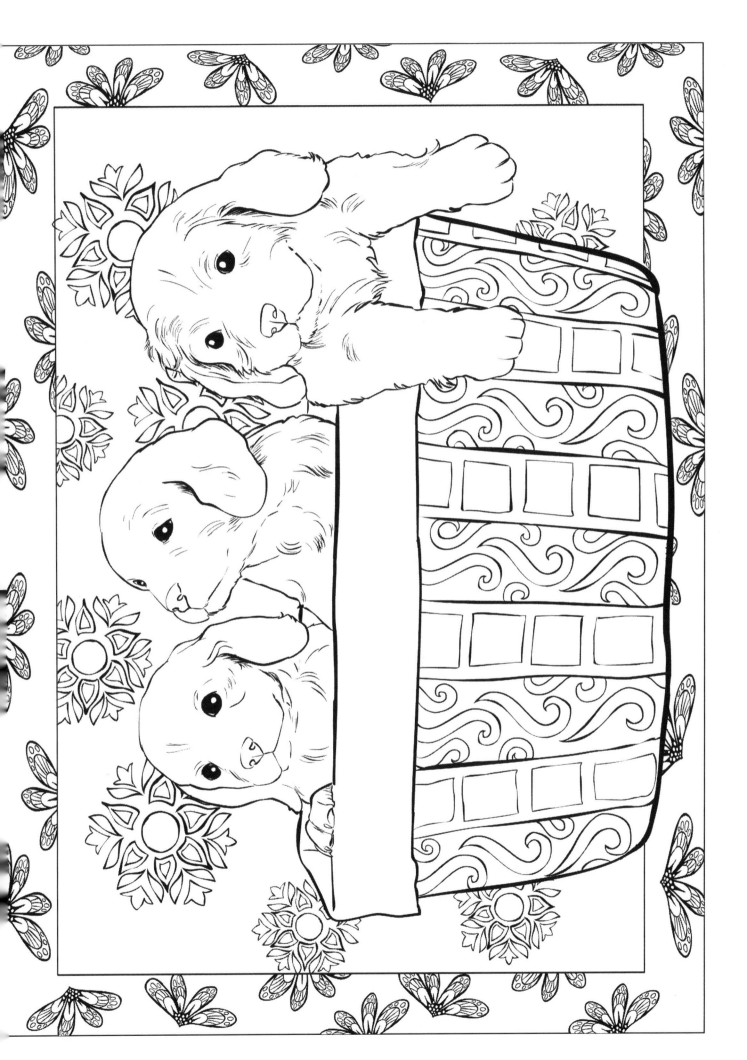

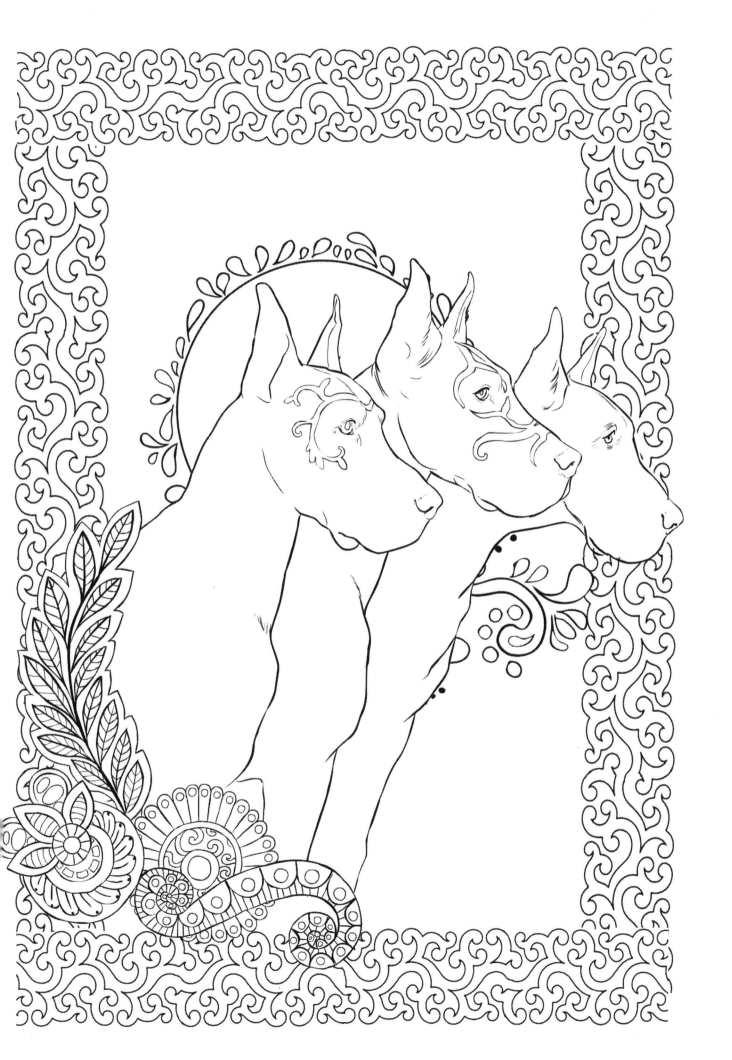

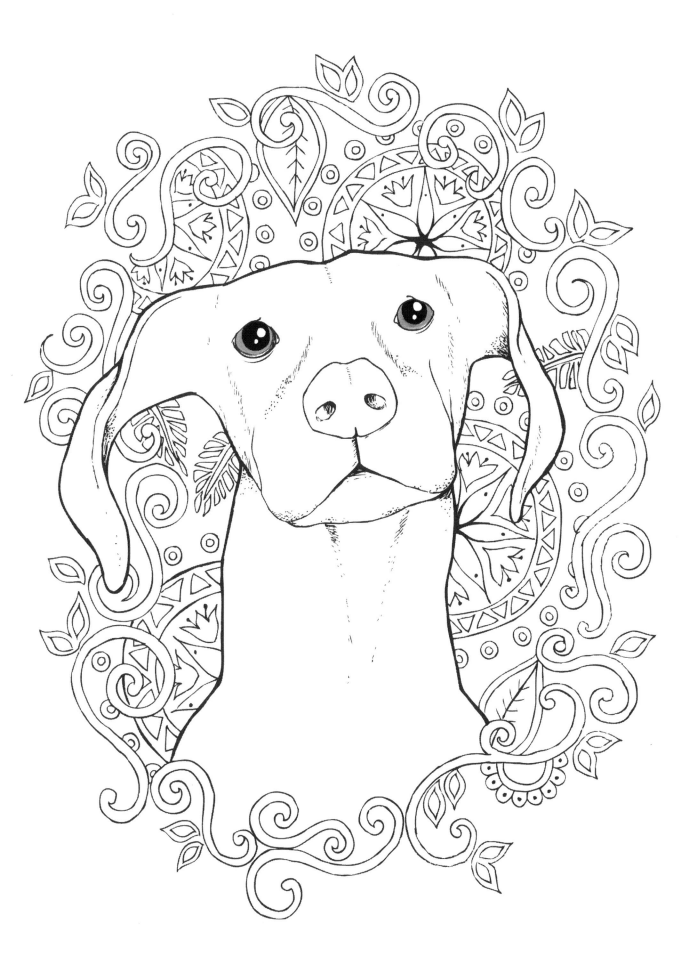

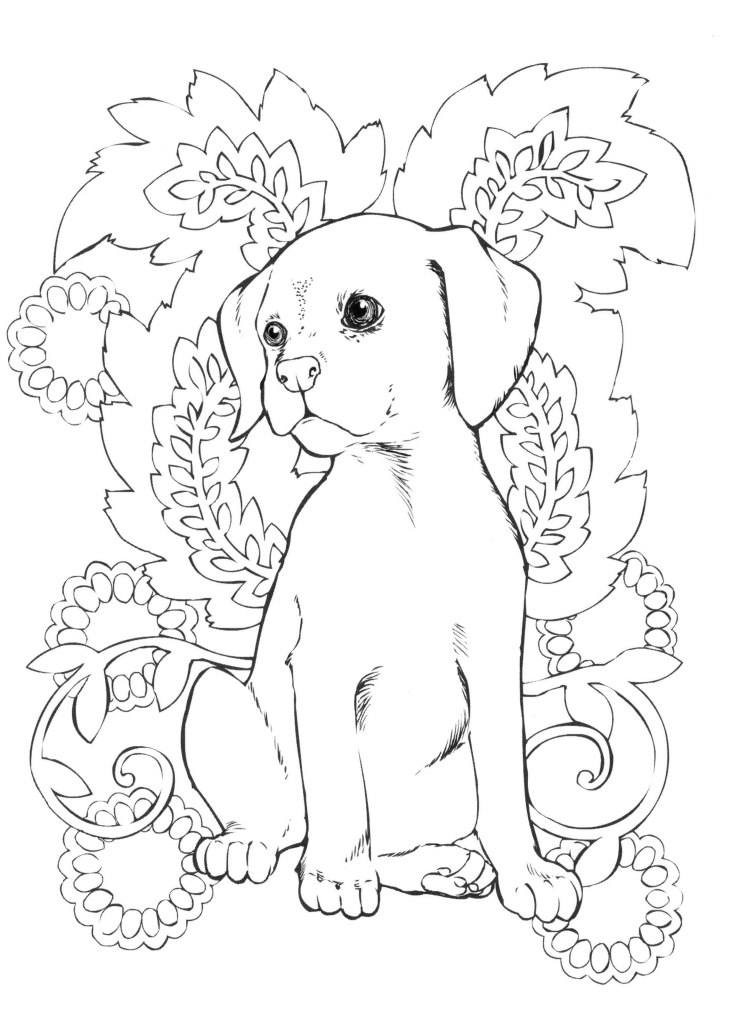

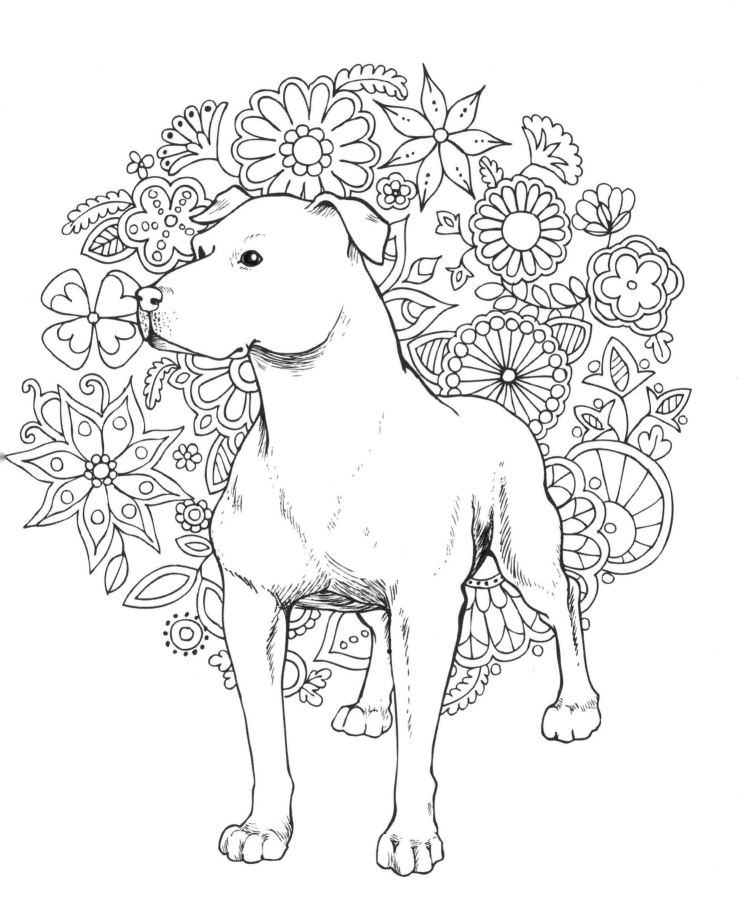

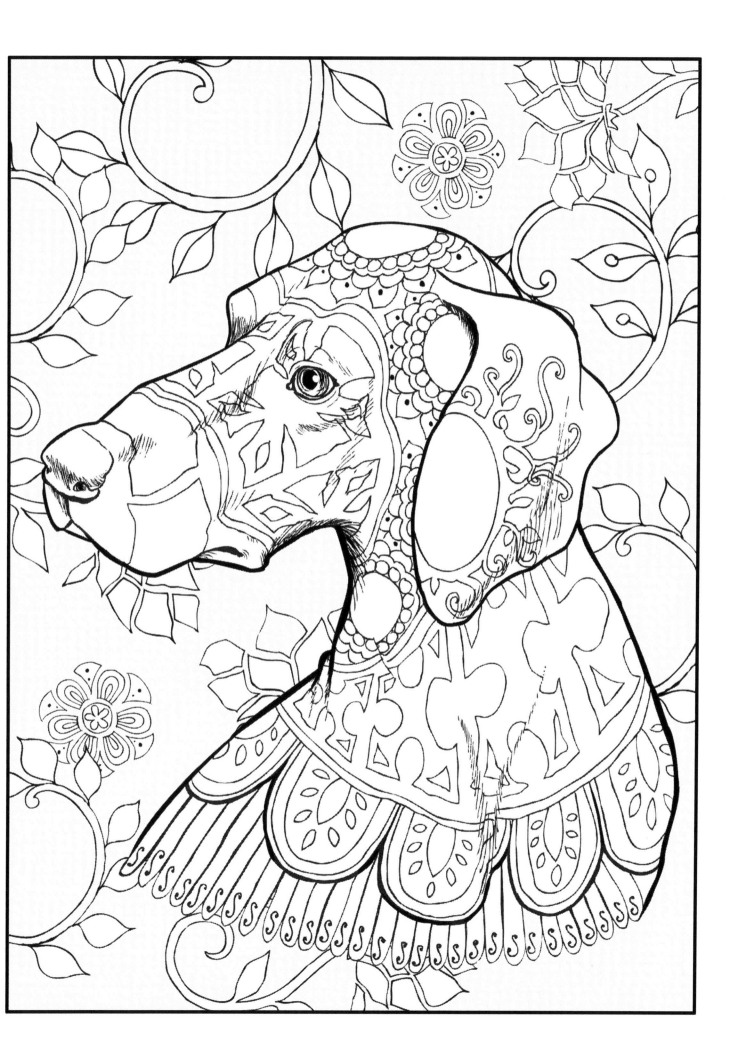

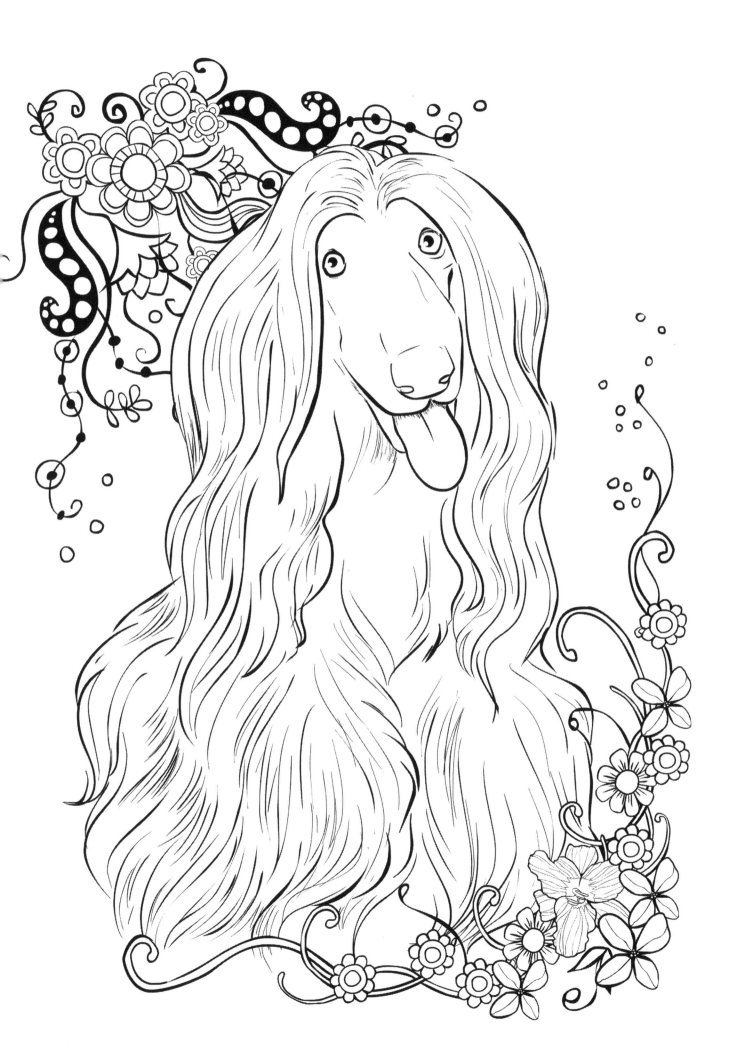

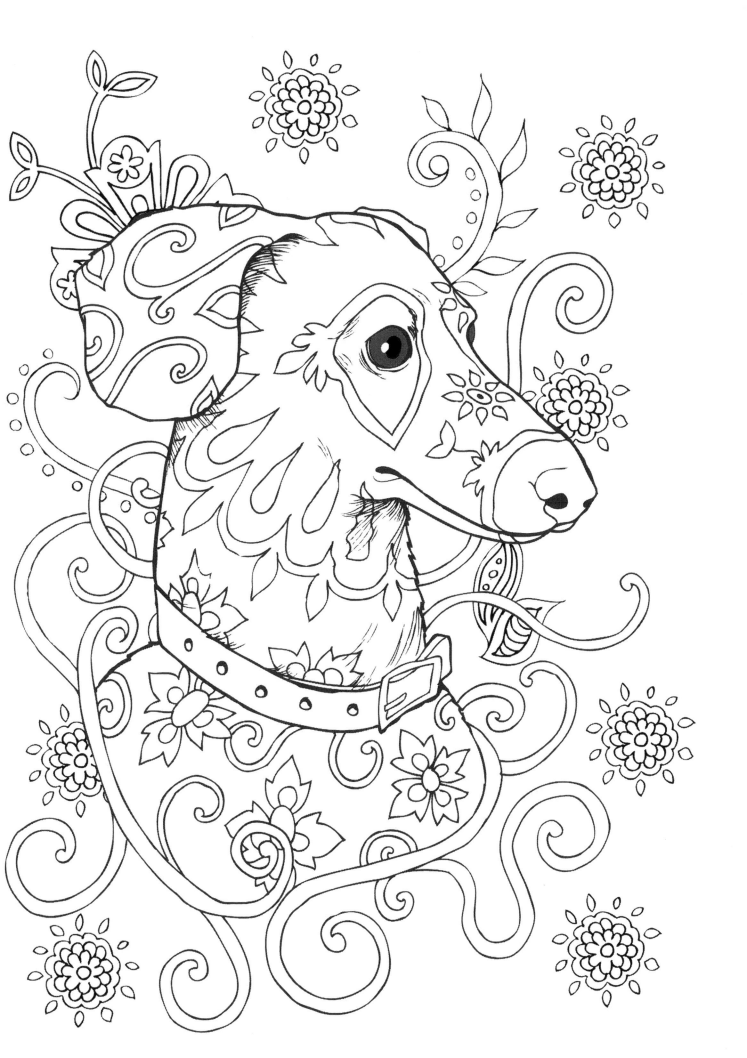

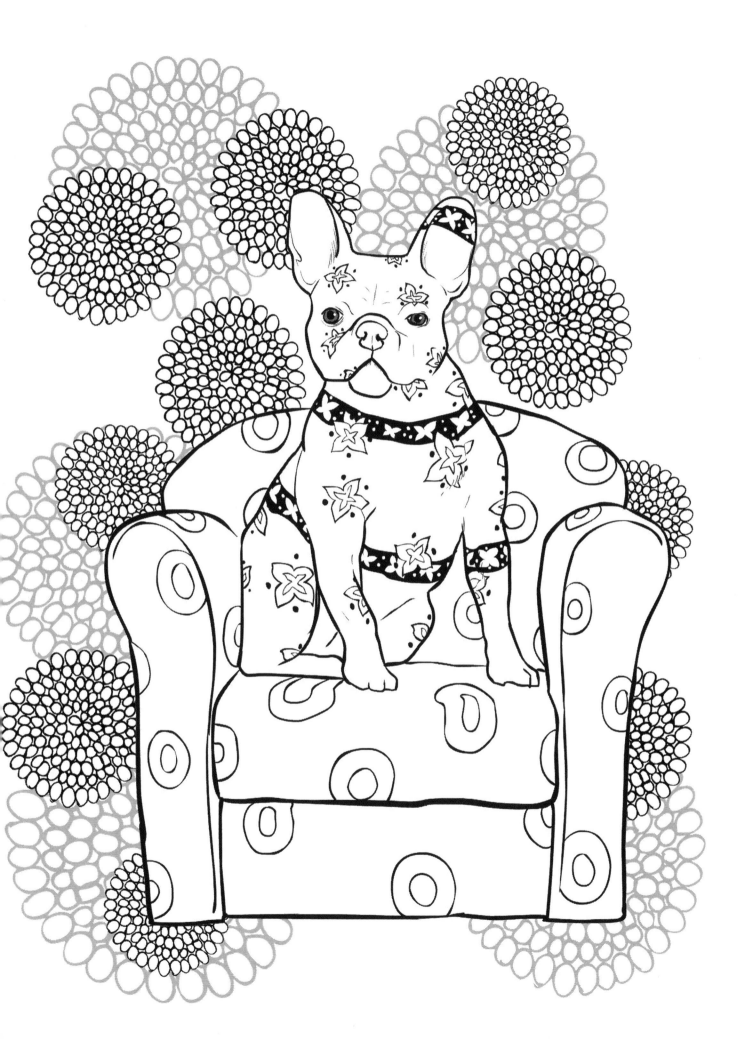

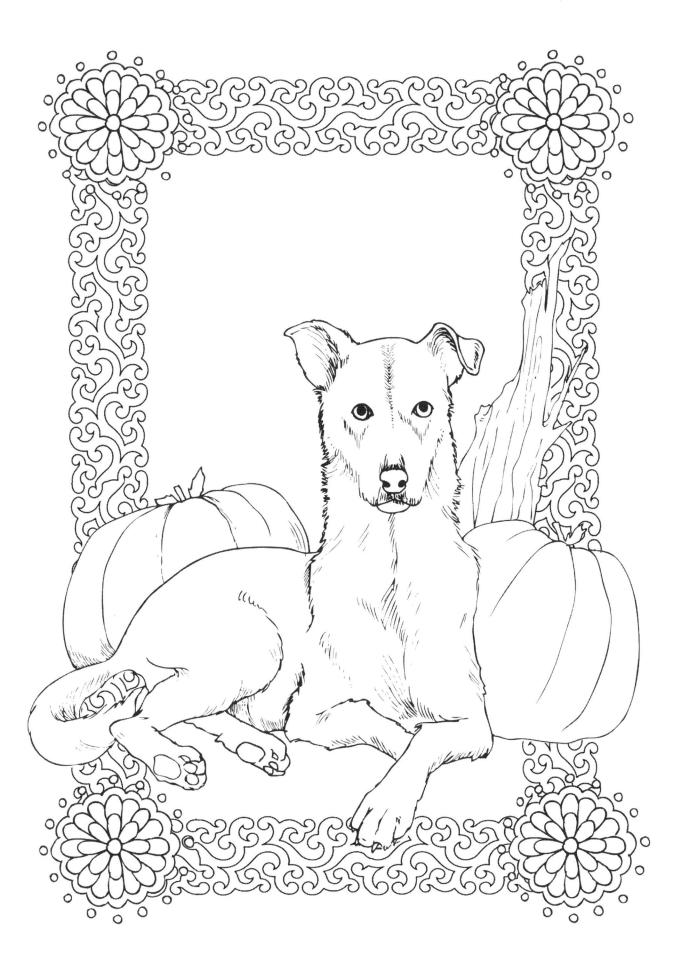

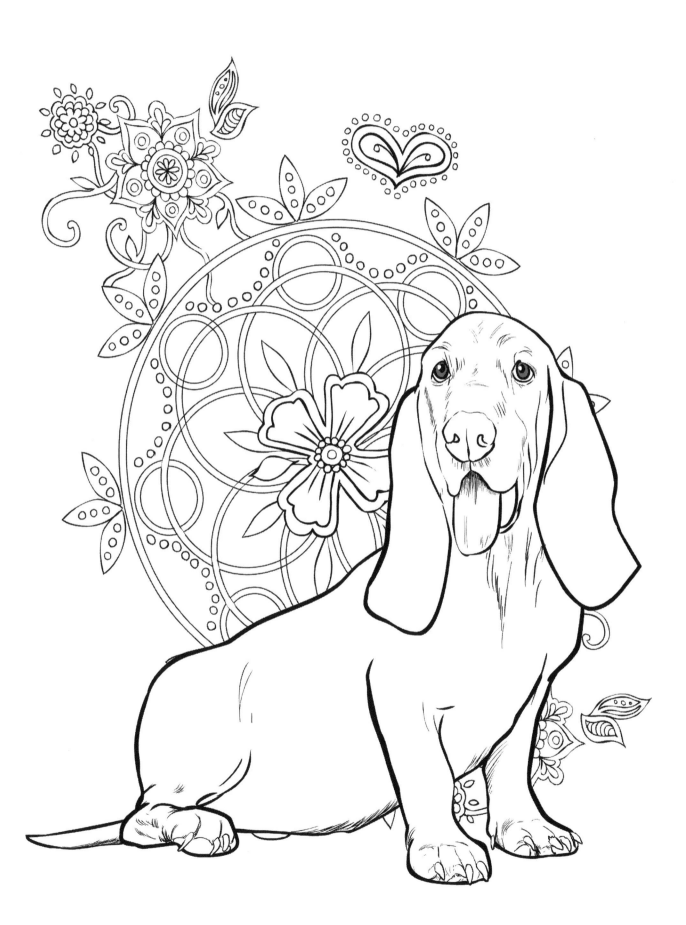

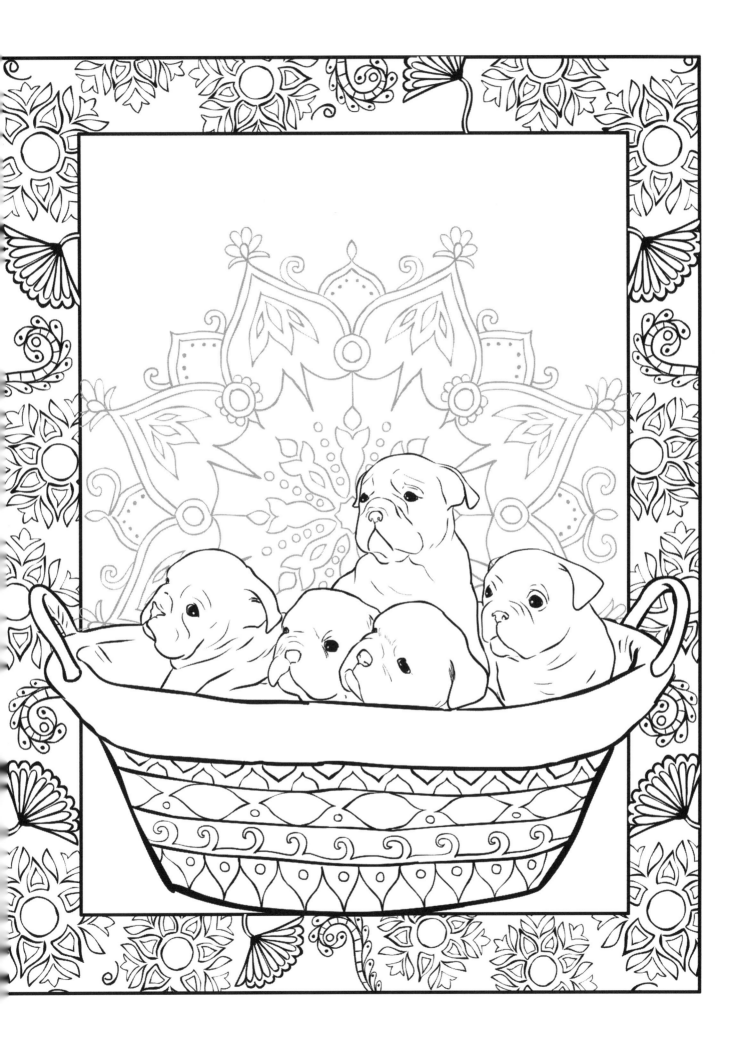

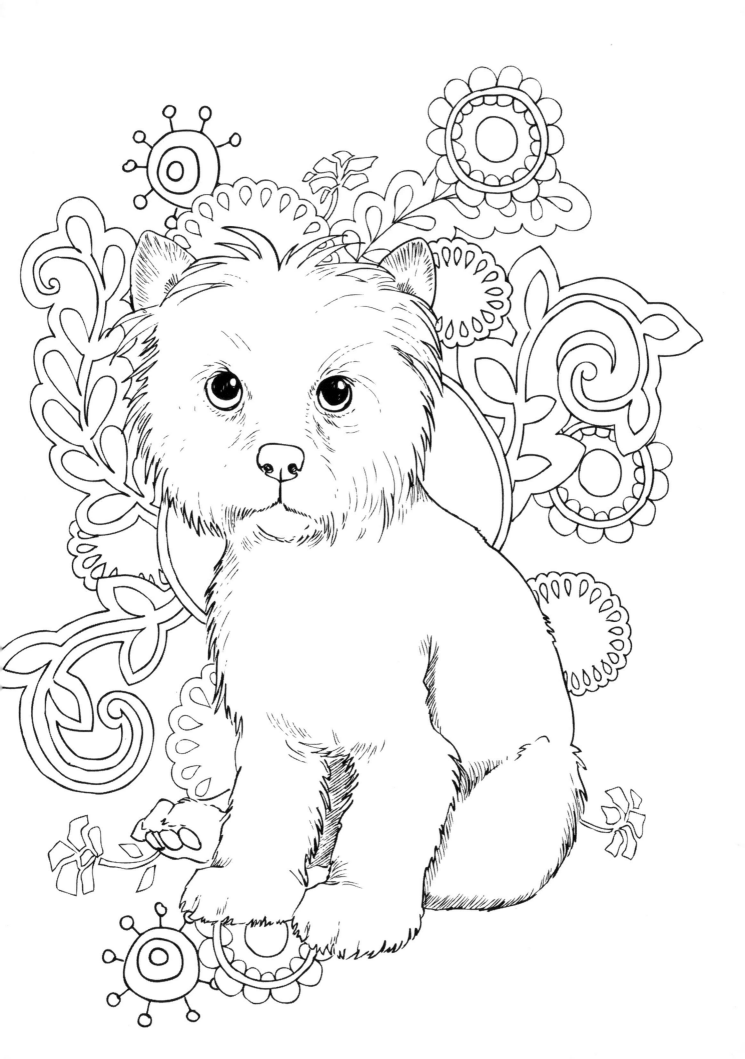

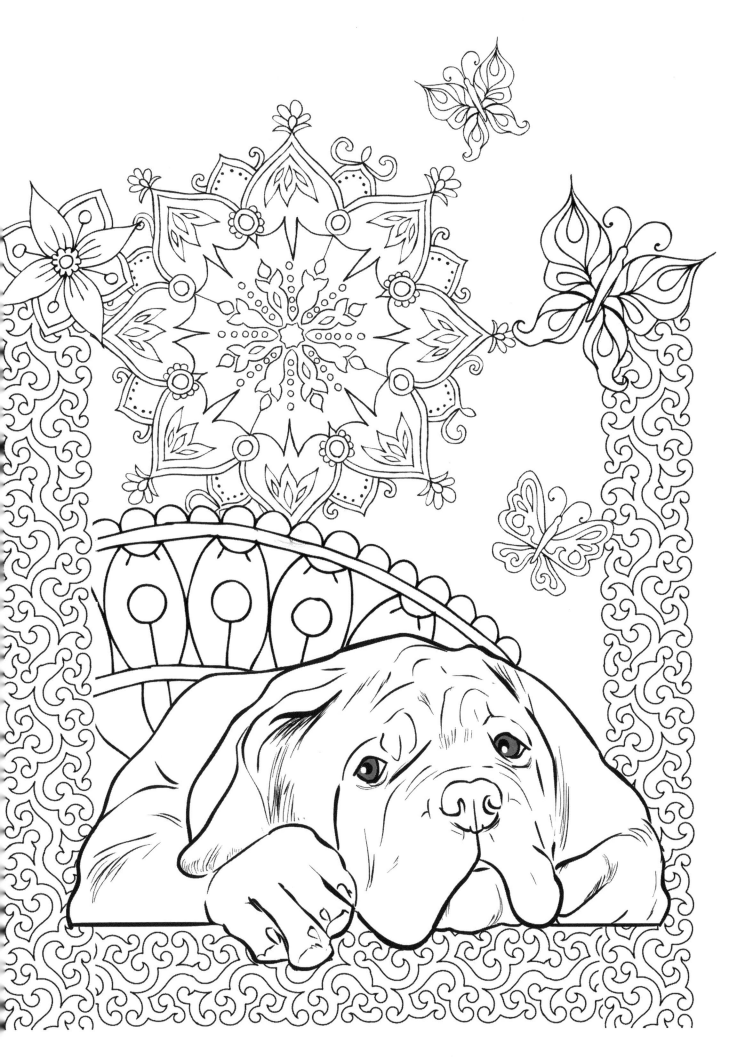

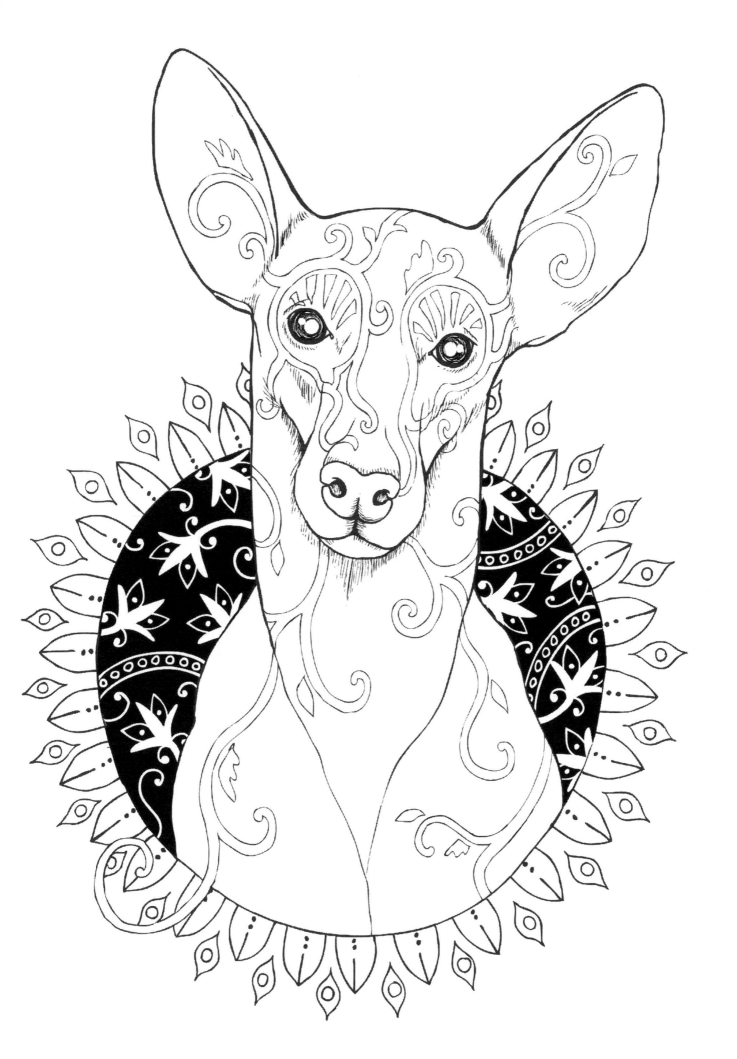

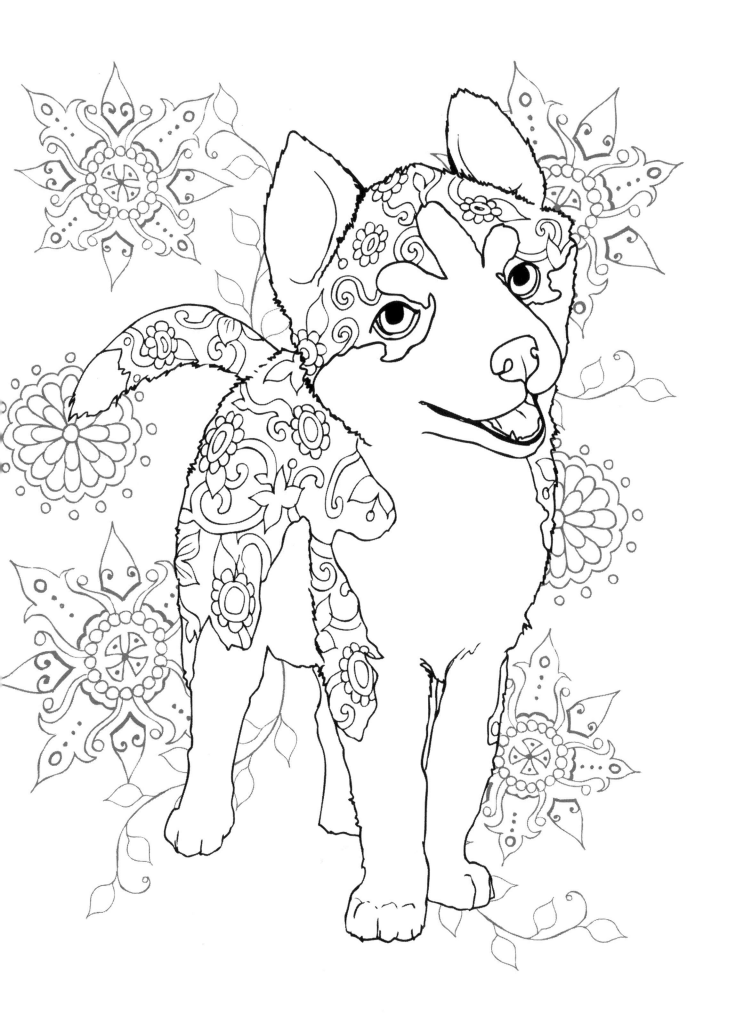

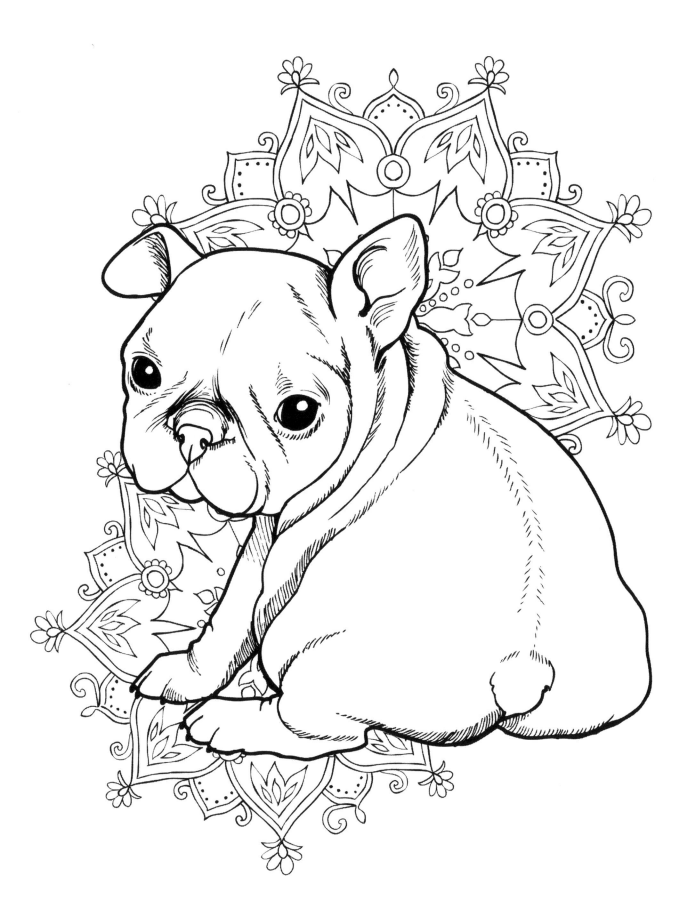

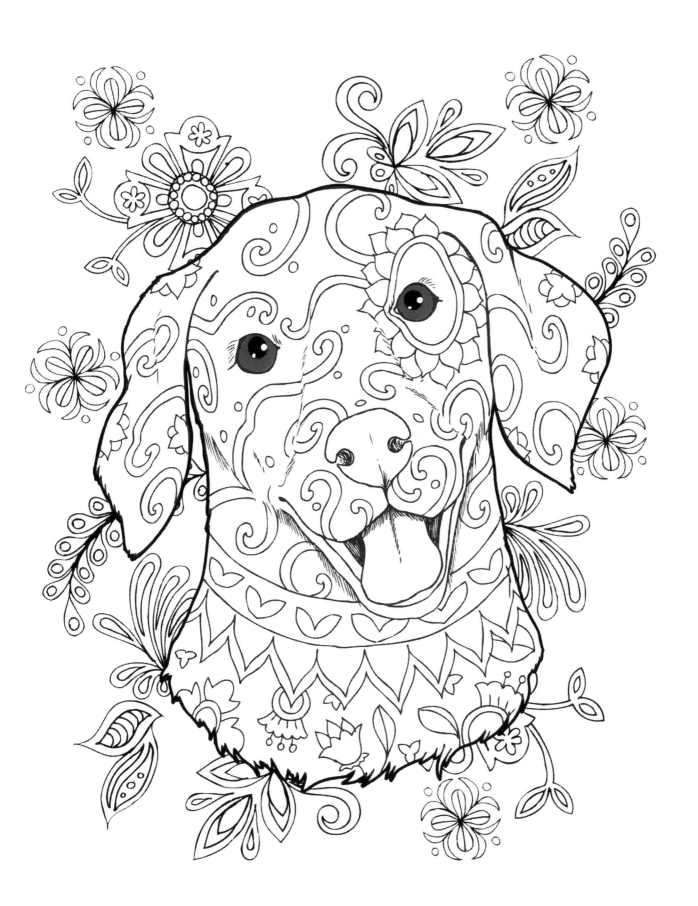

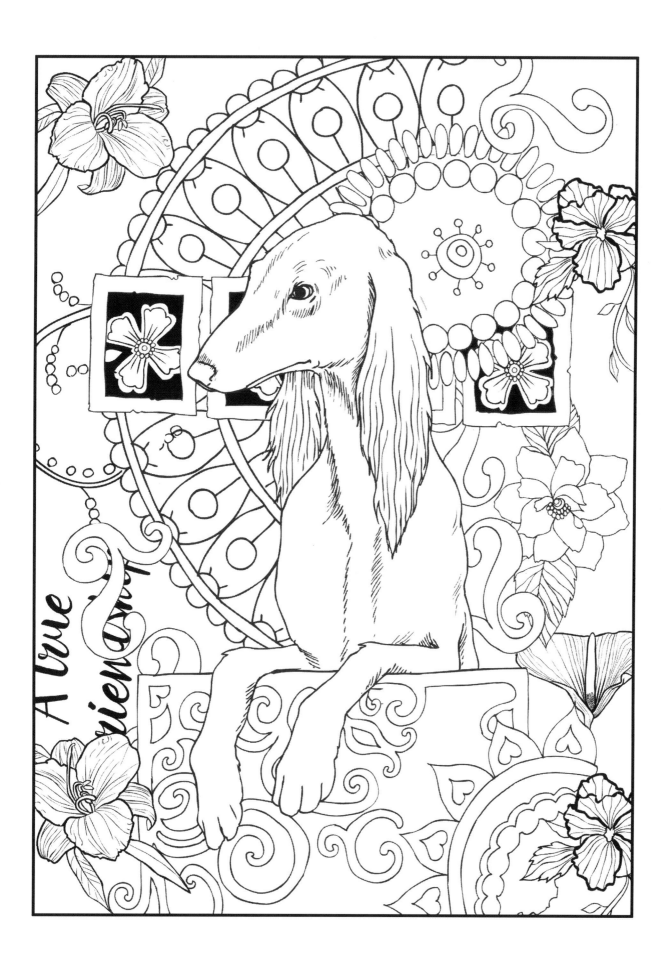

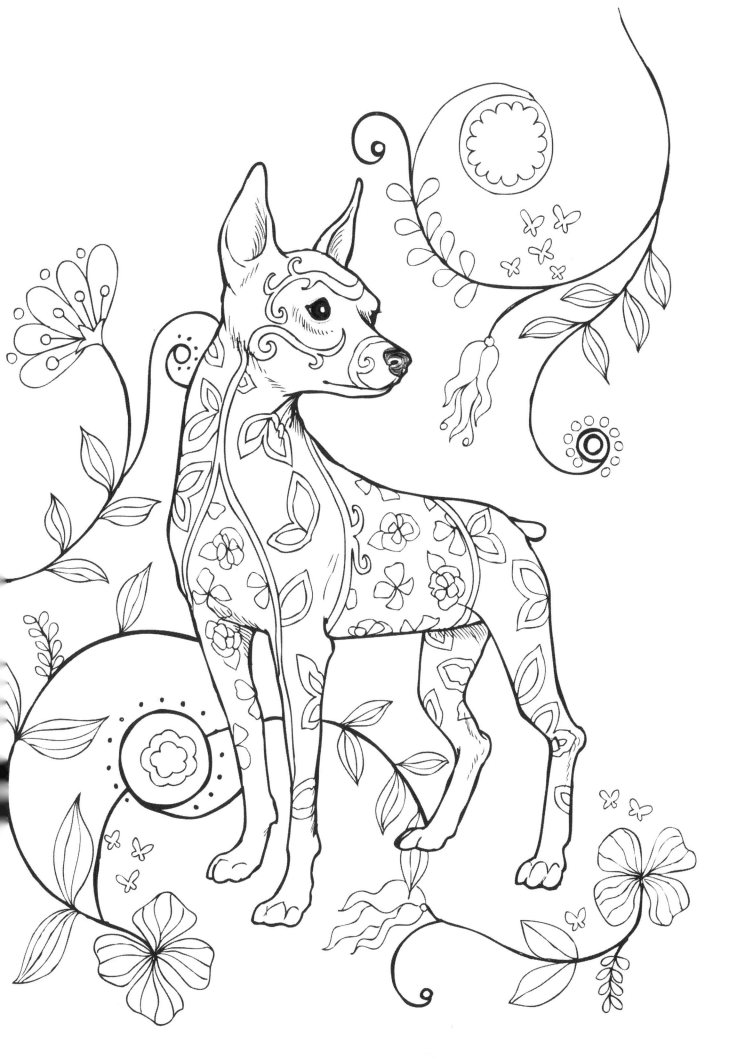

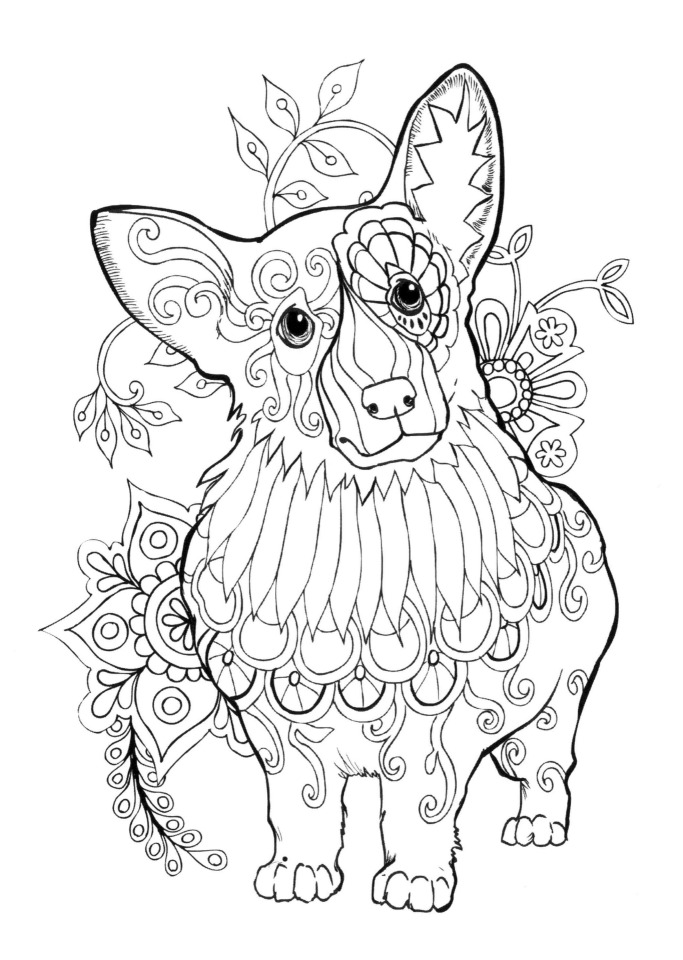

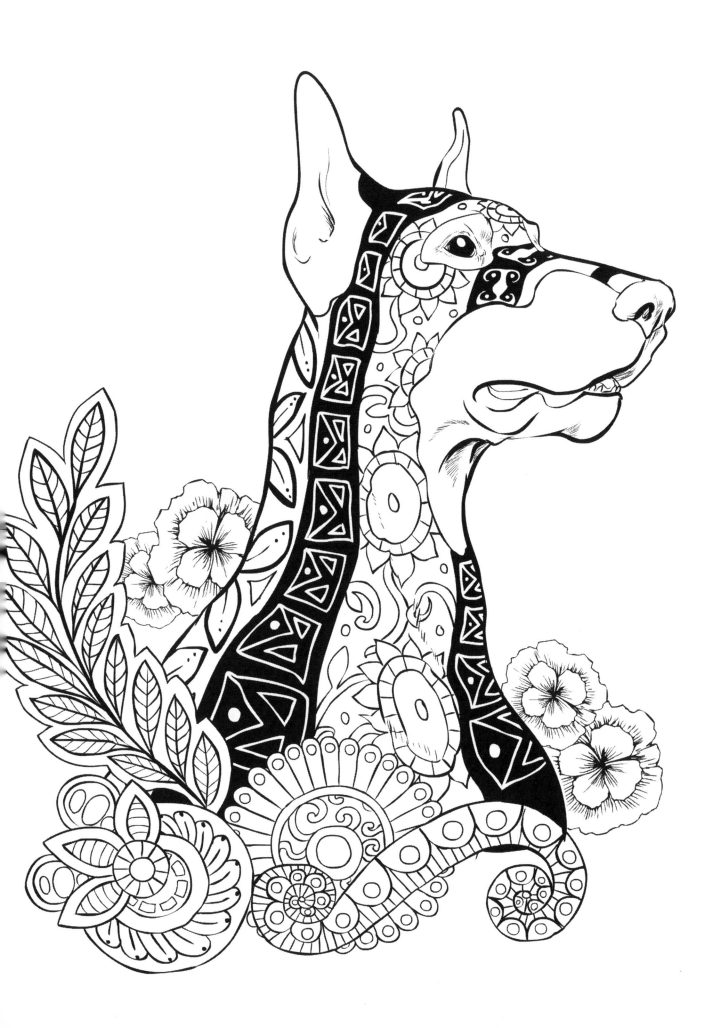

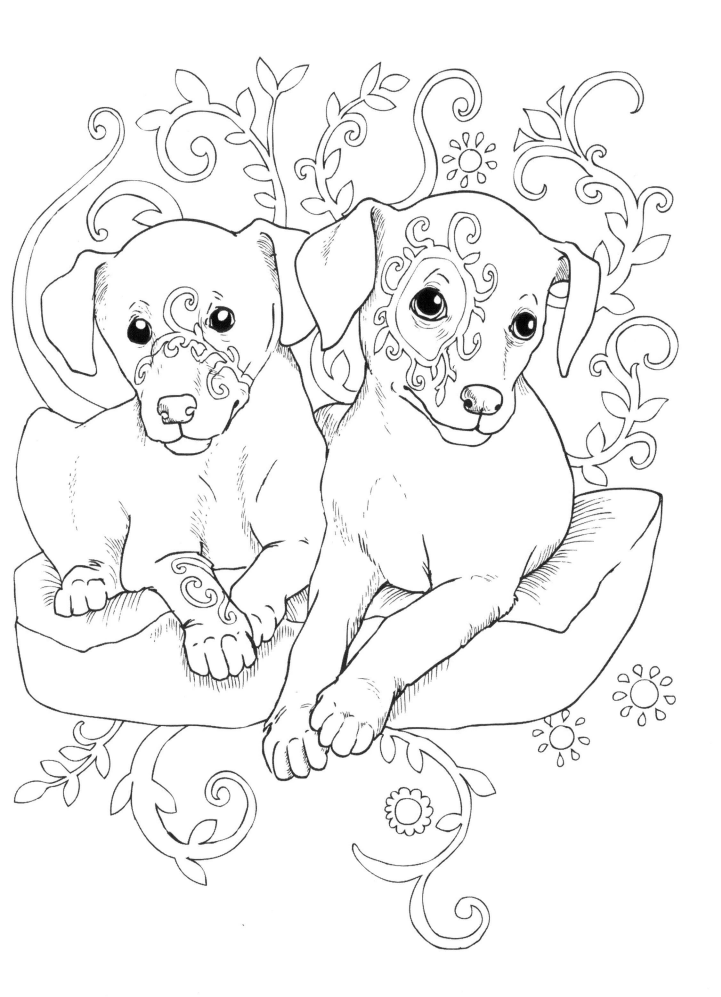

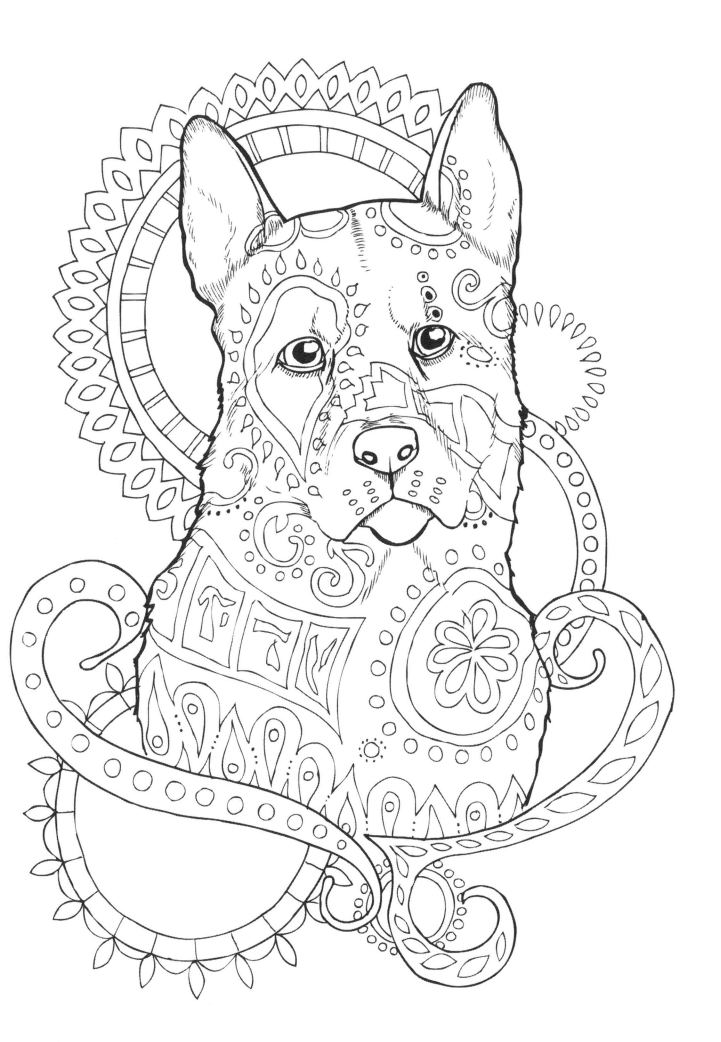

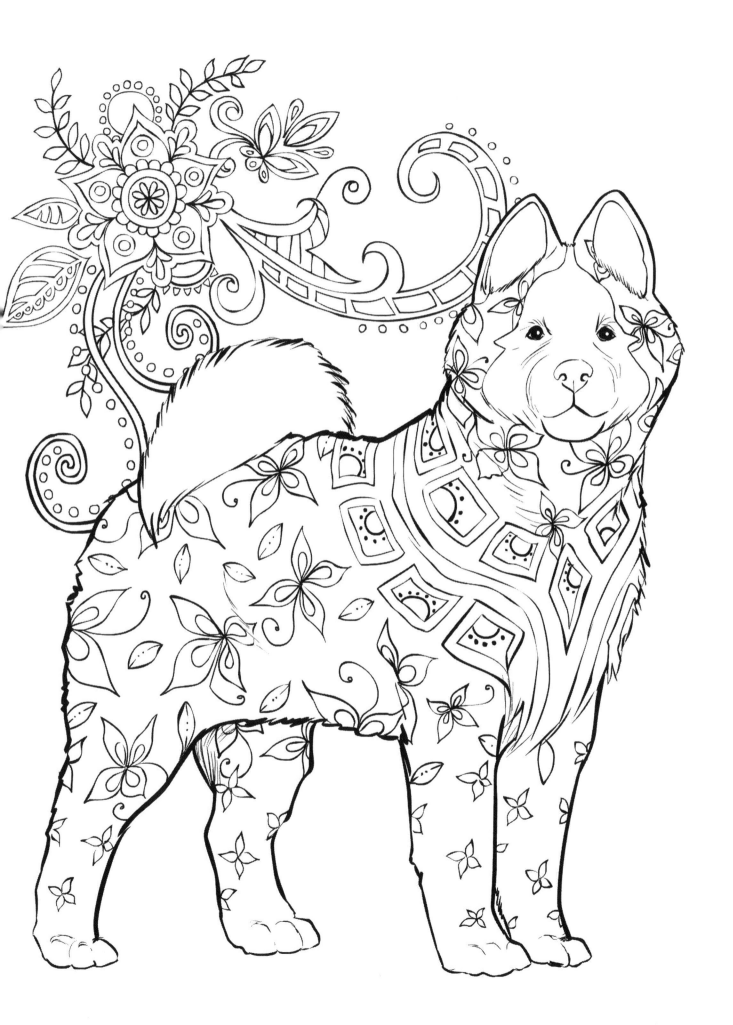

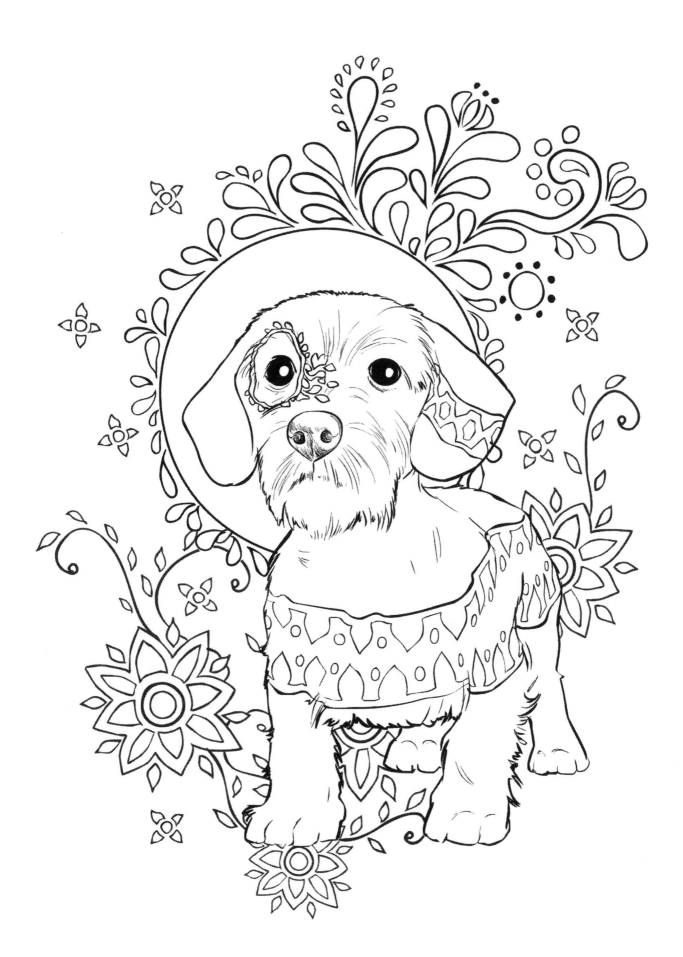

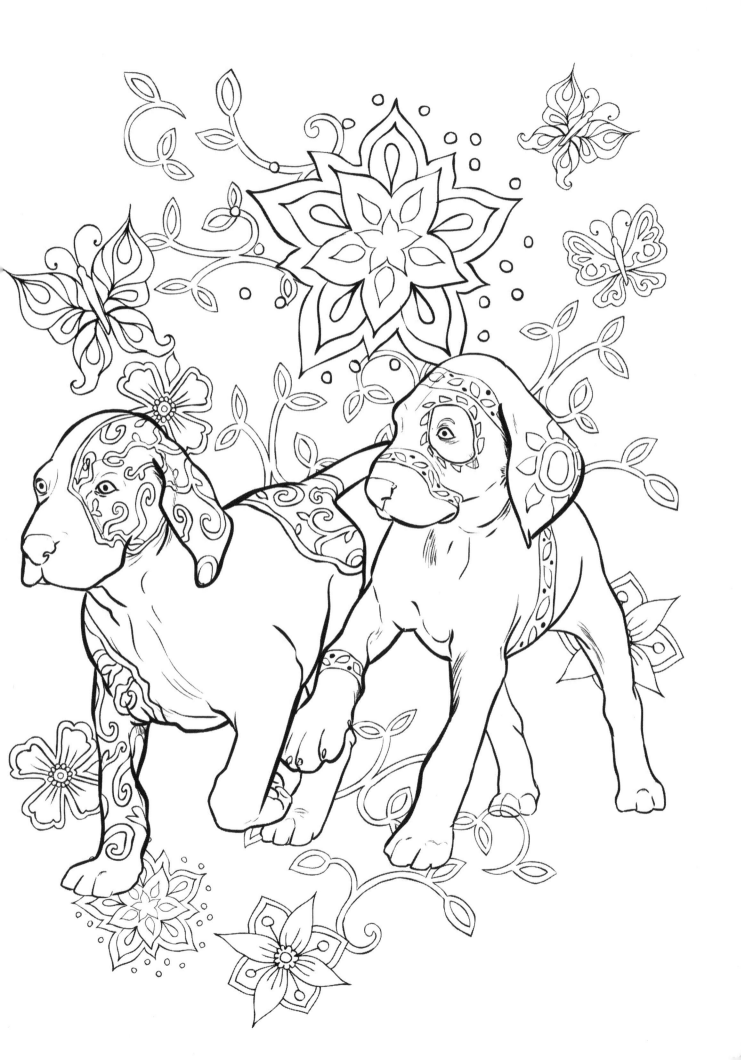

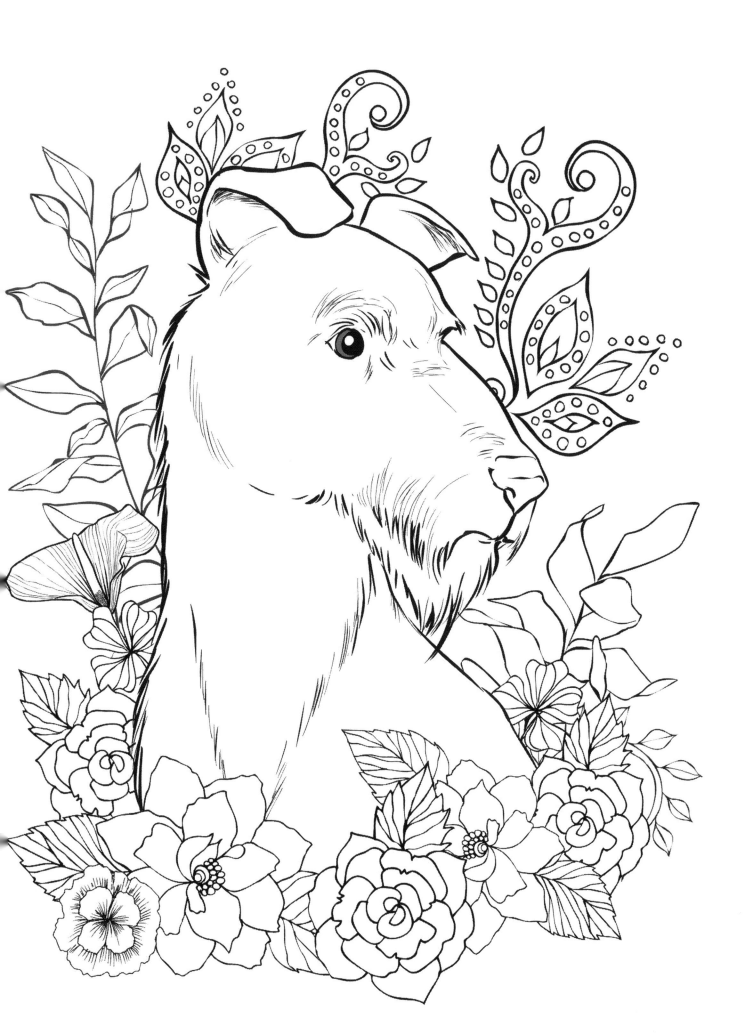

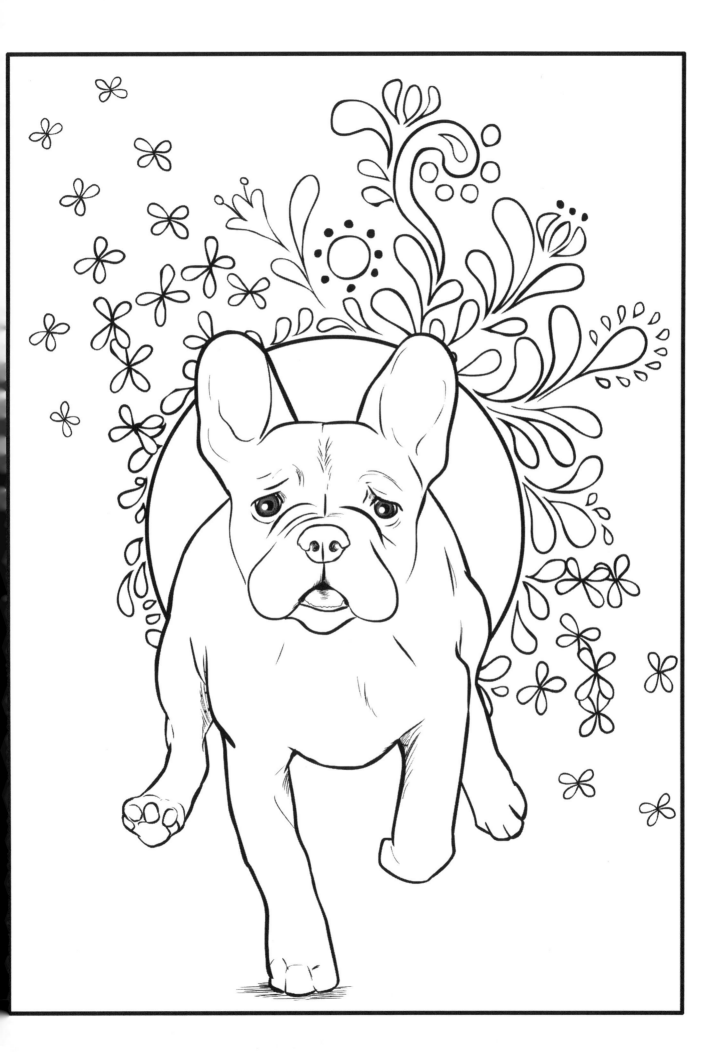

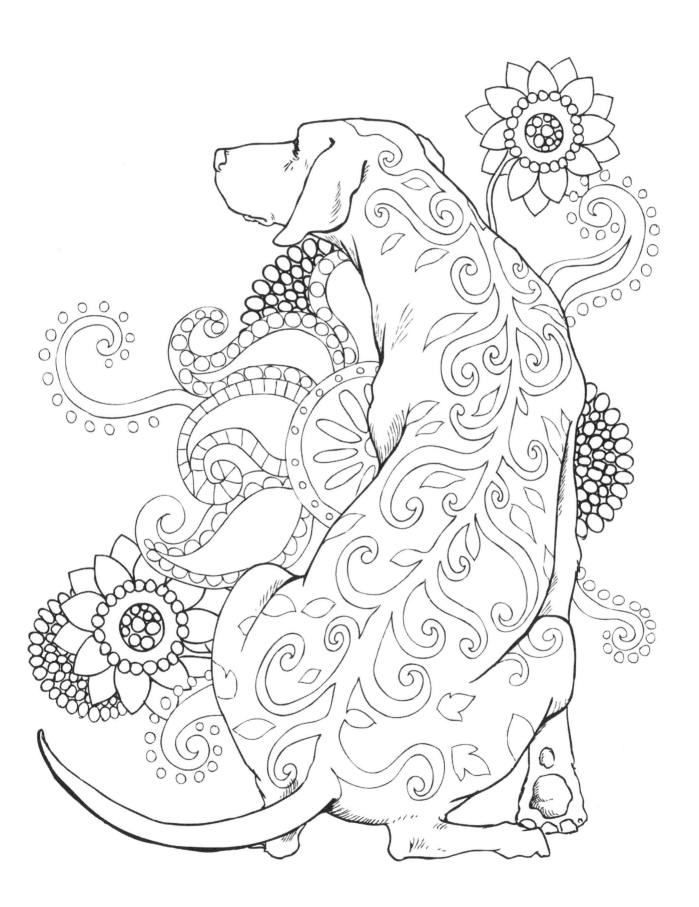

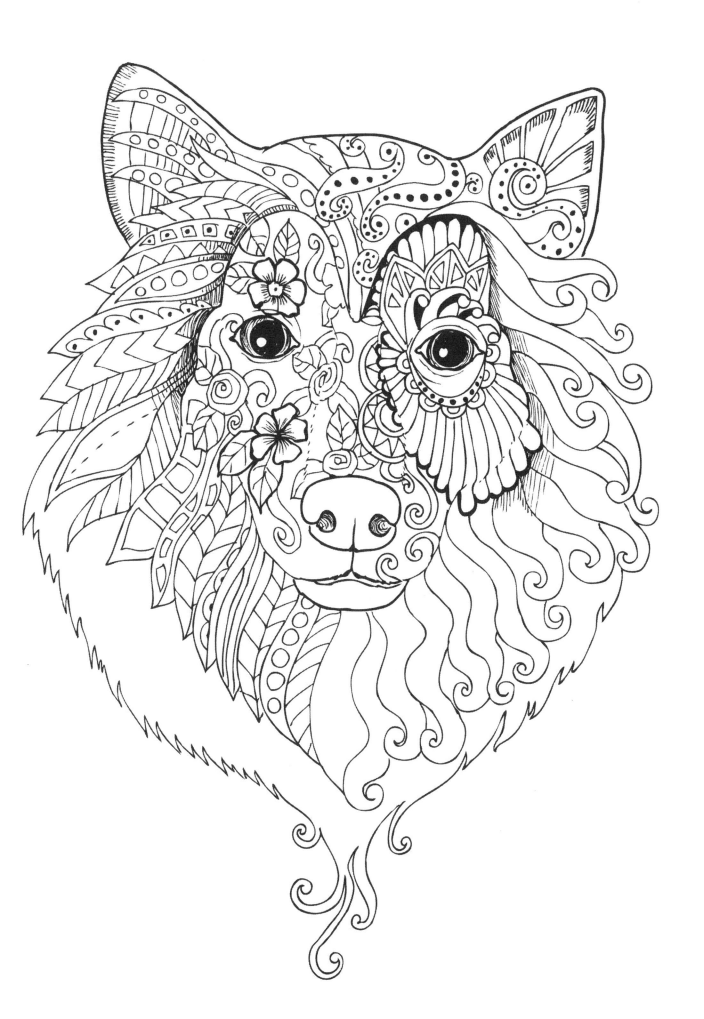

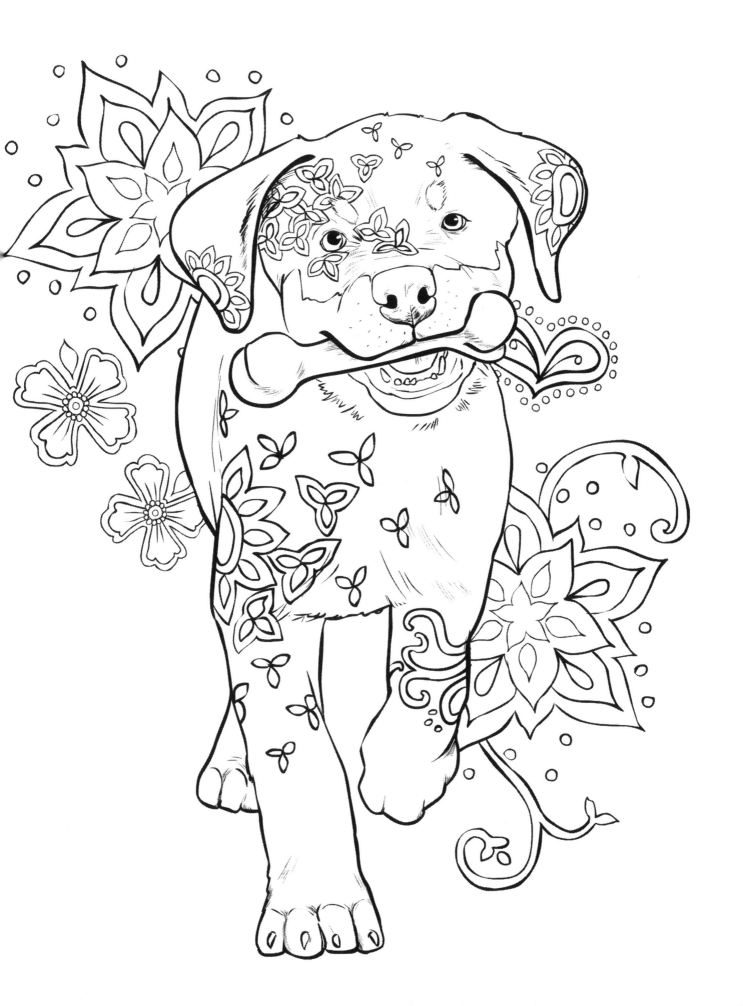

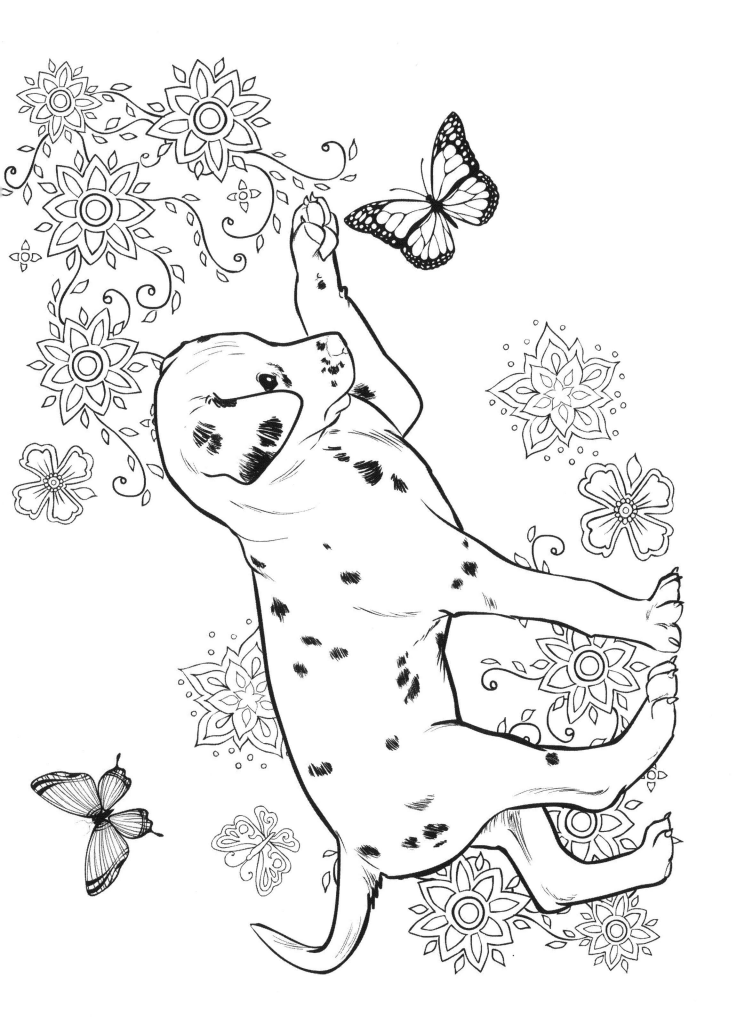

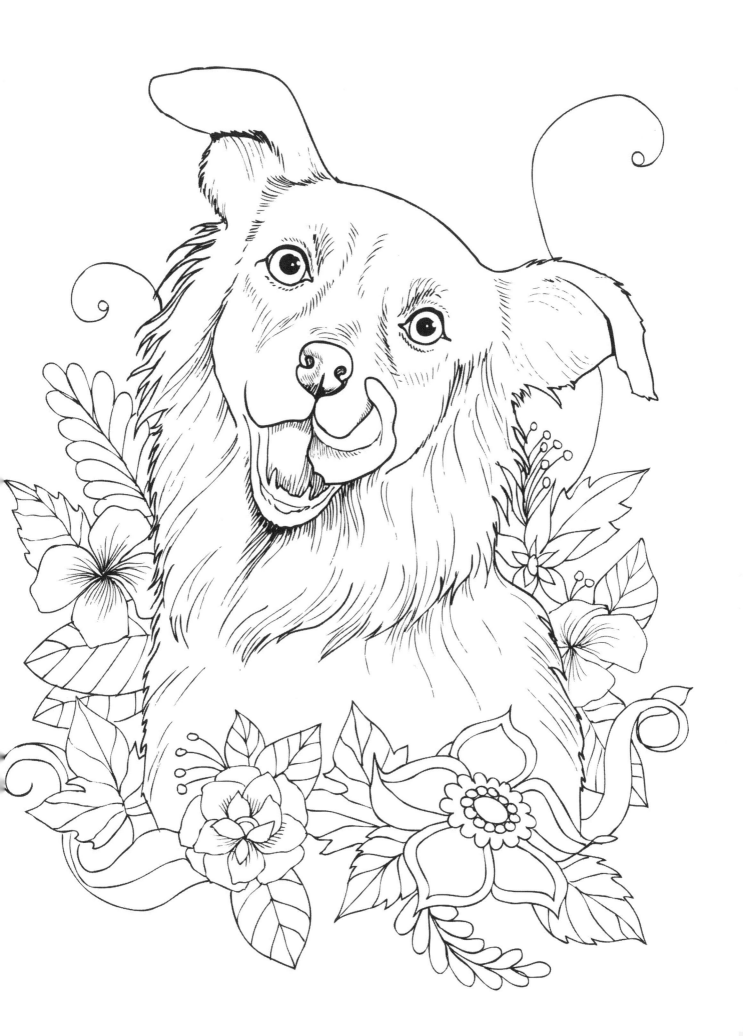

About the Artists

Cindy Elsharouni has been drawing since the age of three. She has developed into a professional fine artist and has held multiple exhibitions internationally. Her main subject matter almost always incorporates animals or humans, particularly faces of people of different backgrounds and walks of life different from her own. She loves to create artwork that has significant meaning and that speaks a message to the viewer.

Tamer Elsharouni is also an achieved professional artist, graduated from the faculty of Fine Arts in Cairo, who has art obtained by collectors worldwide and has his artwork displayed internationally. He has held innumerable private exhibitions and international art awards. He also has a passion to create artwork that impacts people and society as a whole. He speaks at conferences and seminars internationally equipping other artists.

Tamer and Cindy now work on projects together. They have put together this book as an endeavor to allow others who don't like to label themselves as artists, to take part in an artistic process. They believe everyone has the potential to be an artist. Anyone can create in a form of expression.

Together, when possible, they finish off each other's work and also enjoy critiquing each other's work. They hope you enjoy the images in this book but even more so the process.

50582175R00052

Made in the USA
Columbia, SC
08 February 2019